D1409516

12

Dinosaurs
TO
DRAW

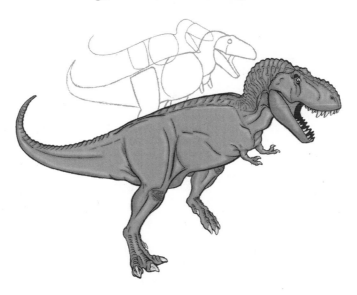

Illustrated by Bryan Baugh

LOWELL HOUSE JUVENILE

LOS ANGELES

NTC/Contemporary Publishing Group

NOTE: The numbered eraser in the upper right-hand corner of each project indicates the level of difficulty—1 being the easiest and 3 the hardest.

Published by Lowell House
A division of NTC/Contemporary Publishing Group, Inc.
4255 West Touhy Avenue, Lincolnwood (Chicago), Illinois 60646-1975 U.S.A.

Copyright © 1999 by NTC/Contemporary Publishing Group, Inc.
All rights reserved. No part of this work may be reproduced, stored in a retrieval system,
or transmitted in any form or by any means, electronic, mechanical, photocopying, recording,
or otherwise, without the prior permission of NTC/Contemporary Publishing Group, Inc.
Requests for such permissions should be sent to the address above.

Managing Director and Publisher: Jack Artenstein
Director of Publishing Services: Rena Copperman
Editorial Director: Brenda Pope-Ostrow
Director of Art Production: Bret Perry
Director of Juvenile Development: Amy Downing
Project Editor: Jessica Oifer
Typesetter: Victor W. Perry

Library of Congress Catalog Card Number: 99-73113
ISBN 0-7373-0198-8

Lowell House books can be purchased at special discounts
when ordered in bulk for premiums and special sales.
Contact Customer Service at the address above,
or call 1-800-323-4900.

Printed and bound in the United States of America
ML 10 9 8 7 6 5 4 3 2 1

HICAGO PUBLIC LIBRARY
NEAR NORTH BRANCH
310 W. DIVISION
CHICAGO, IL 60610

Contents

Apatosaurus

ACCORDING TO SCIENTISTS, WHEN THE APATOSAURUS MOVED ITS GIANT 45-FOOT (14-M) TAIL, IT PROBABLY CREATED A LOUD, ALMOST SONICLIKE BOOM.

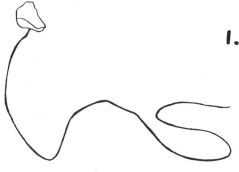

1. Begin by drawing the outline of the Apatosaurus's head. Attach the top of its neck, body, and tail.

2. Complete its neck and body, and sketch its eye and snout line.

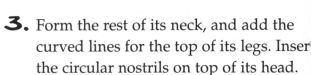

3. Form the rest of its neck, and add the curved lines for the top of its legs. Insert the circular nostrils on top of its head.

4. Continue to create its legs, and add muscle definition to its body.

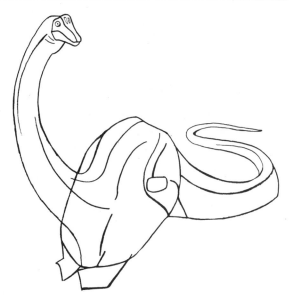

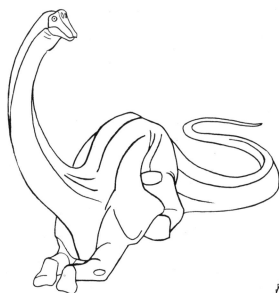

5. Finish its legs, making sure to add hooflike feet. Draw more muscle definition, and erase any unneeded lines.

6. Finally, draw scales on the Apatosaurus's head, body, and tail. Also, add toes to the visible back foot, and sketch wrinkles where shown.

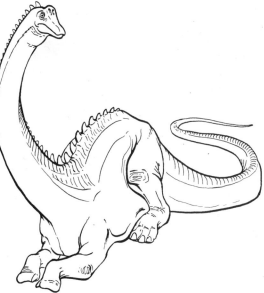

Diplodocus

AT 88 TO 100 FEET (26.8 TO 31 M) LONG, THE DIPLODOCUS WAS ONE OF THE LONGEST ANIMALS THAT EVER LIVED.

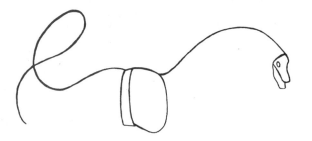

1. Sketch the top part of the Diplodocus's neck, body, and curvy tail. Draw its face, body, and hip. Insert its eye and mouth.

2. Complete its neck and tail, and form two of its legs.

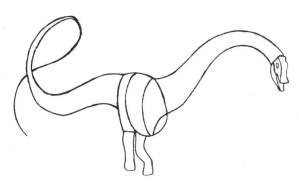

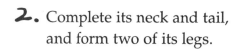

3. Begin to create muscle definition, and further detail its head. Add its second set of legs, and then erase unneeded lines.

4. Draw the scales on its back, and insert its teeth. Add more muscle definition, and refine its legs. Sketch claws and a kneecap. Erase additional unneeded lines.

Ouranosaurus

SCIENTISTS BELIEVE THAT THE TALL, SAIL-LIKE HUMP ON THIS DINOSAUR'S BACK MAY HAVE HELPED IT CONTROL ITS BODY TEMPERATURE.

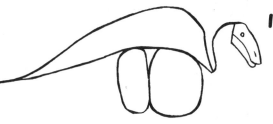

1. Outline the Ouranosaurus's head, and then begin to form its neck, back, and tail. Sketch the rest of its body and hip, and attach its sail-like hump. Insert its eye and nostril.

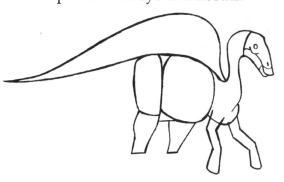

2. Complete its neck, and further detail its face. Form its legs as shown.

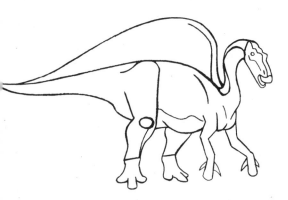

3. Draw muscle definition on its body and neck. Add feet and the small humps on its head. Erase unneeded lines.

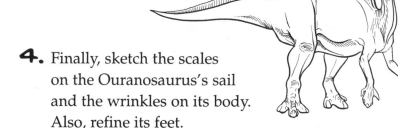

4. Finally, sketch the scales on the Ouranosaurus's sail and the wrinkles on its body. Also, refine its feet.

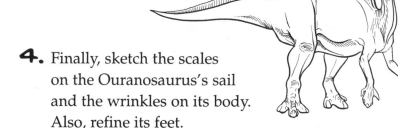

Therizinosaurus

THE THERIZINOSAURUS MAY HAVE USED ITS HUGE CLAWS FOR PROTECTION FROM ENEMIES, AS WELL AS TO GATHER INSECTS TO EAT.

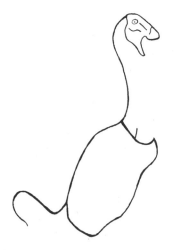

1. Sketch this dinosaur's head and body. Then attach part of its neck and tail. Add detail to its face, including its visible eye.

2. Render the rest of its neck and tail, and continue to detail its face.

3. Add muscle definition to its neck. Draw the top sections of its arms and legs, including its visible kneecap.

4. Add the second section of its arms and legs, and refine its neck line.

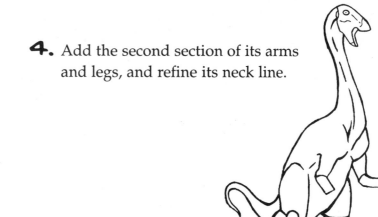

5. Draw its sharp claws and back feet. Add the spikes on top of its head, and erase any unneeded lines.

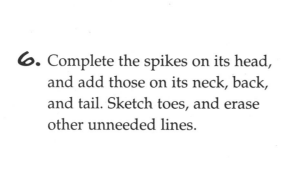

6. Complete the spikes on its head, and add those on its neck, back, and tail. Sketch toes, and erase other unneeded lines.

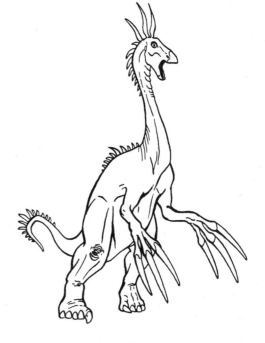

Amargosaurus

THE AMARGOSAURUS WAS A MEMBER OF THE SAUROPOD FAMILY. SAUROPODS WERE FOUR-LEGGED, PLANT-EATING DINOSAURS WITH LONG NECKS AND TAILS AND SMALL HEADS.

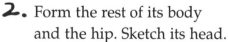

1. Begin by sketching the top of this dinosaur's neck, body, and tail.

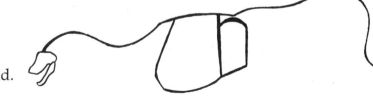

2. Form the rest of its body and the hip. Sketch its head.

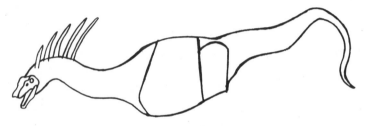

3. Begin to add detail to its face, and complete its neck and tail. Draw the spines on its neck.

4. Outline the large spiny sail along the Amargosaurus's back. Begin to form its legs, and add the line on its neck.

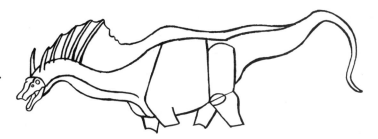

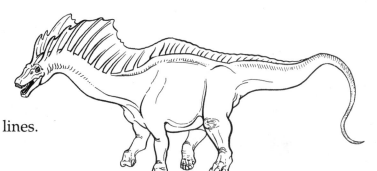

5. Further render its sail, and sketch its lower leg sections. Add muscle definition, teeth, and eye pupil. Erase unneeded lines.

6. Complete its legs, adding toes and muscle lines as shown. Also, shade the spine and sketch wrinkles to add depth to your drawing. Erase any additional unneeded lines.

Saltasaurus

THE SALTASAURUS'S BACK WAS COVERED WITH THICK, BONY ARMOR, WHICH HELPED PROTECT IT FROM ITS ENEMIES.

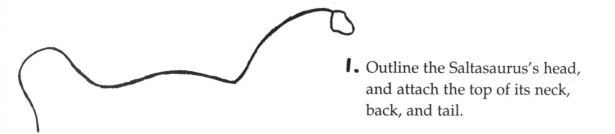

1. Outline the Saltasaurus's head, and attach the top of its neck, back, and tail.

2. Add its body and hip.

3. Complete its neck and tail, and draw its eye and mouth.

4. Now add lines defining the Saltasaurus's muscles. Also, begin to create its front legs.

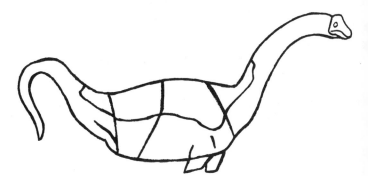

5. Sketch the bottom section of its front legs, and create its back legs. Be sure to add the kneecap. Add more muscle lines, and erase any unneeded lines.

6. Refine the legs, and erase any more unneeded lines. Further detail the Saltasaurus's face, and render the bony armor on its back and the spikes on its head and tail.

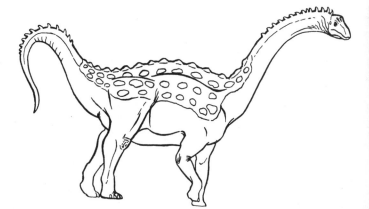

THE REMAINS OF THE IGUANODON WERE THE FIRST DINOSAUR REMAINS EVER DISCOVERED BY A SCIENTIST.

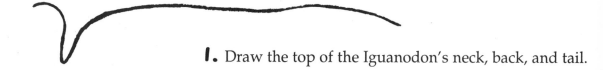

1. Draw the top of the Iguanodon's neck, back, and tail.

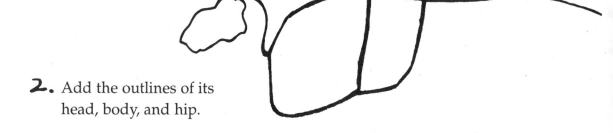

2. Add the outlines of its head, body, and hip.

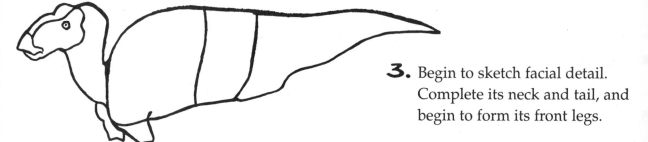

3. Begin to sketch facial detail. Complete its neck and tail, and begin to form its front legs.

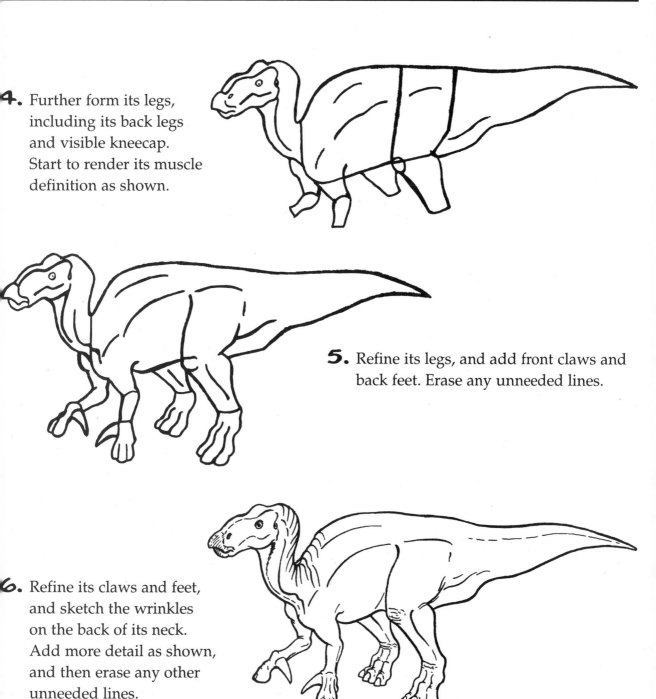

4. Further form its legs, including its back legs and visible kneecap. Start to render its muscle definition as shown.

5. Refine its legs, and add front claws and back feet. Erase any unneeded lines.

6. Refine its claws and feet, and sketch the wrinkles on the back of its neck. Add more detail as shown, and then erase any other unneeded lines.

Euoplocephalus

THE EUOPLOCEPHALUS IS KNOWN FOR ITS THICK, SPIKED BODY ARMOR AND DEADLY CLUBLIKE TAIL.

1. To begin, outline this dinosaur's head, neck, and body. Attach part of its tail.

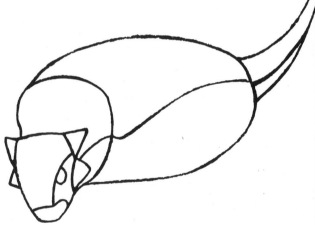

2. Sketch its horns, eye, and snout. Complete its tail, and begin to define its plate of back armor.

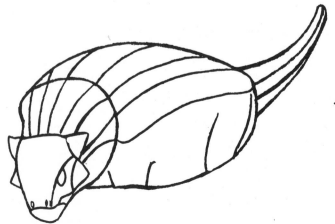

3. Insert its nostrils, and begin to render its back armor.

4. Continue to define its armor, and add facial detail. Attach part of its clubbed tail, and begin to form its legs.

5. Add its sharp spikes and four feet. Further render its tail, and then erase unneeded lines.

6. Draw more spikes. Then refine your drawing, adding detail as shown. Erase additional unneeded lines.

Stegosaurus

ONE OF THE MOST FAMOUS OF ALL DINOSAURS, THE STEGOSAURUS'S MOST EFFECTIVE WEAPON WAS ITS FLEXIBLE SPIKED TAIL.

1. First draw the top of the Stegosaurus's neck, body, and tail.

2. Sketch the outline of its head, and complete its body and tail. Begin to form one of its legs.

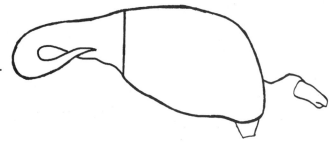

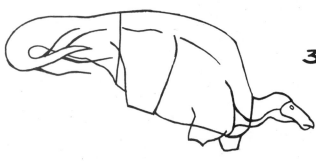

3. Draw the upper section of its other front leg and its visible hip. Add detail to its face, muscle lines on its body, and some of its tail spikes.

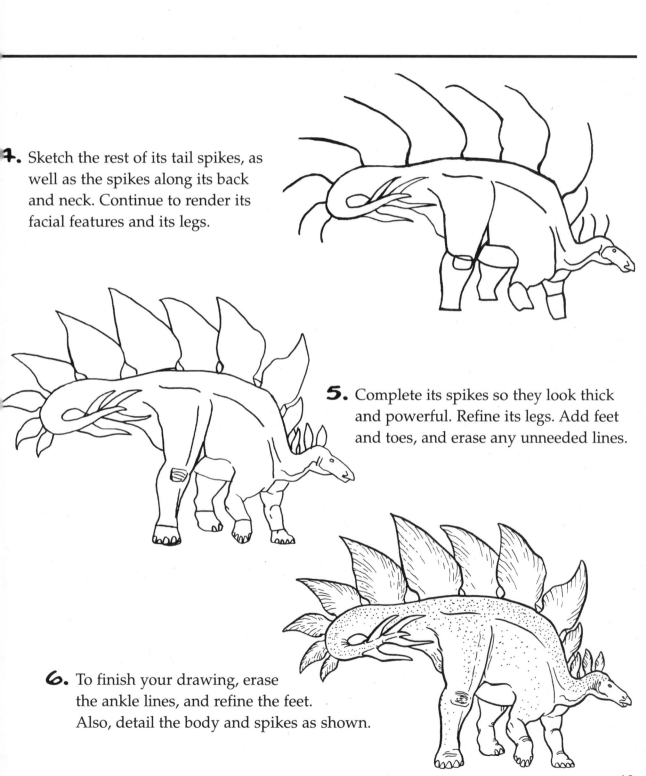

4. Sketch the rest of its tail spikes, as well as the spikes along its back and neck. Continue to render its facial features and its legs.

5. Complete its spikes so they look thick and powerful. Refine its legs. Add feet and toes, and erase any unneeded lines.

6. To finish your drawing, erase the ankle lines, and refine the feet. Also, detail the body and spikes as shown.

Tenontosaurus

THE LARGE, PLANT-EATING TENONTOSAURUS IS BELIEVED TO HAVE BEEN HUNTED BY PACKS OF MEAT-EATING DEINONYCHUS.

1. Draw part of this dinosaur's neck, back, and tail.

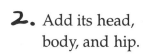

2. Add its head, body, and hip.

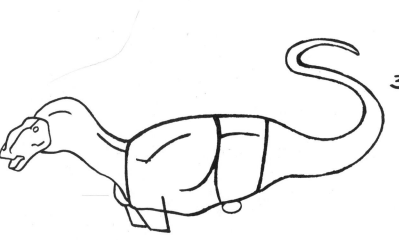

3. Begin to add facial detail and form its front legs. Finish its neck and tail, attach its back kneecap, and sketch muscle definition.

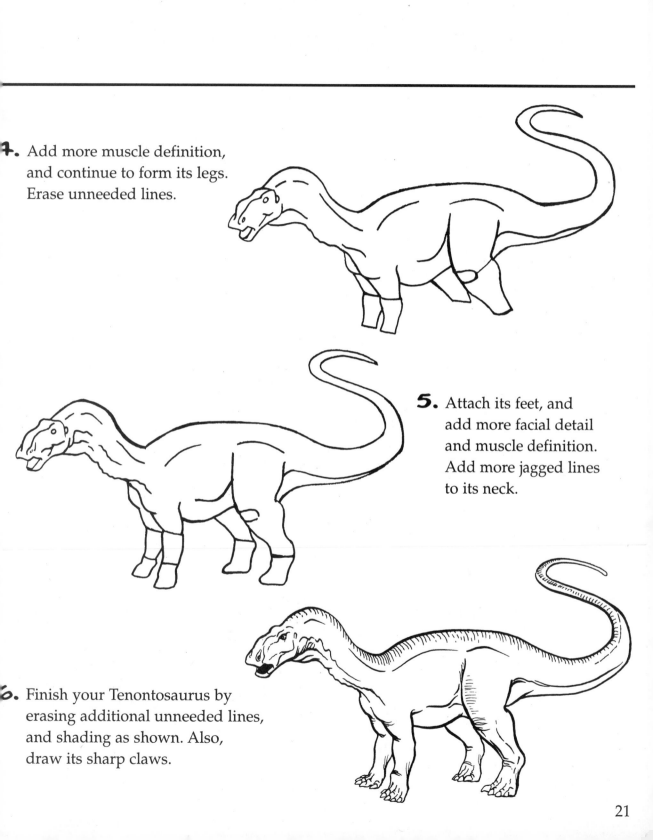

4. Add more muscle definition, and continue to form its legs. Erase unneeded lines.

5. Attach its feet, and add more facial detail and muscle definition. Add more jagged lines to its neck.

6. Finish your Tenontosaurus by erasing additional unneeded lines, and shading as shown. Also, draw its sharp claws.

THE PACHYCEPHALOSAURUS LIVED DURING THE CRETACEOUS PERIOD THAT MEANS IT ROAMED EARTH ABOUT 67 MILLION YEARS AGO.

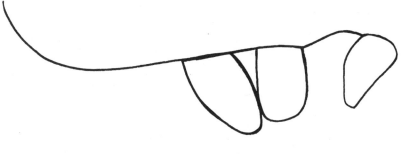

1. First draw this dinosaur's head, body, and hip. Attach the top of its neck and tail.

2. Form its eye and mouth, and complete its neck. Begin to render its arms and legs.

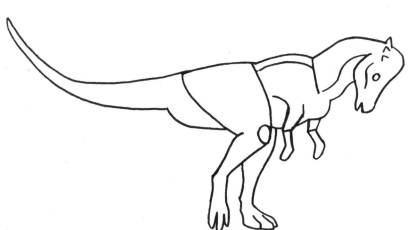

3. Add its ears, and begin to create muscle definition. Finish outlining its arms, legs, and tail. Erase unneeded lines.

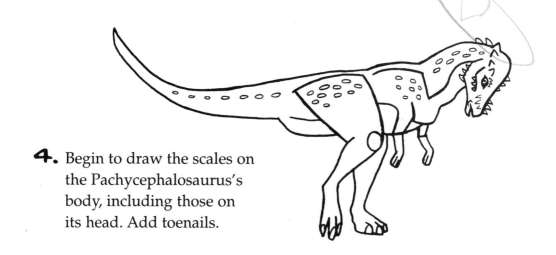

4. Begin to draw the scales on the Pachycephalosaurus's body, including those on its head. Add toenails.

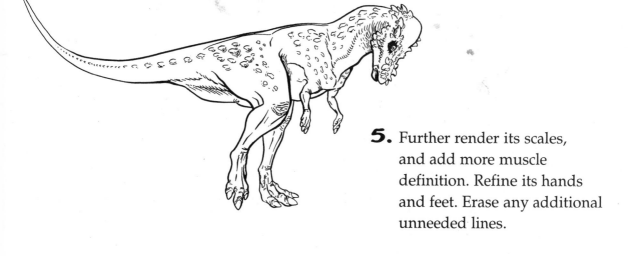

5. Further render its scales, and add more muscle definition. Refine its hands and feet. Erase any additional unneeded lines.

Stygimoloch

THE STYGIMOLOCH WAS A SMALLER VERSION OF THE PACHYCEPHALOSAURUS WITH LONG HORNS ON ITS HEAD.

1. Begin by outlining the Stygimoloch's head, body, and hip. Add the top of its neck and tail.

2. Sketch its eye, mouth, and the small horns growing around its skull. Complete its neck and tail, adding muscle lines. Begin to form its arms and legs, adding its front paws.

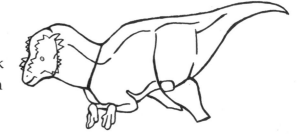

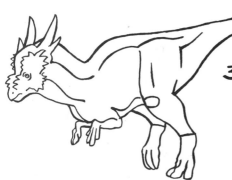

3. Attach the large horns jutting from the top of its head. Add its feet and more muscle definition. Erase unneeded lines.

4. Finish by drawing spines down the Stygimoloch's back and refining the details on its arms and legs. Also add the spots and wrinkles on its body where shown.

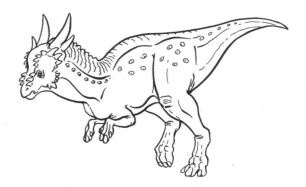

Scelidosaurus

RELATED TO BOTH THE ANKYLOSAURUS AND STEGOSAURUS, THIS TOUGH LITTLE DINOSAUR WAS COVERED FROM HEAD TO FOOT WITH THICK, BONY ARMOR.

1. Draw the outline of the Scelidosaurus's head, body, and hip. Attach the top of its neck and long tail.

2. Outline its neck and tail. Begin to render its legs and feet, and draw its eye. Draw some muscle definition and the bony armor on its neck. Erase unneeded lines.

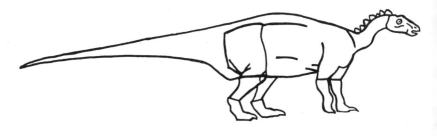

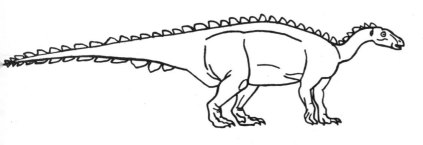

3. Further refine its legs and feet. Erase unneeded lines, and then attach the rest of the scales.

4. Create the dark shading over the dinosaur's eye, and then draw the armor and the wrinkles on its body.

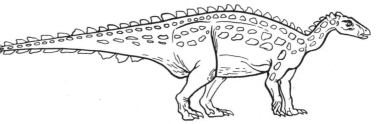

Chasmosaurus

THE GREAT SIZE OF THE CHASMOSAURUS'S HORNED HEAD FRILL MADE IT APPEAR MUCH LARGER THAN IT REALLY WAS.

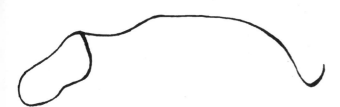

1. Draw the outline of the dinosaur's head, and the top of its neck, back, and tail.

2. Attach its body, and add its eye and mouth.

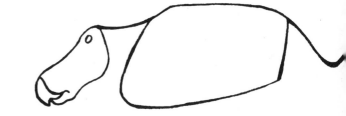

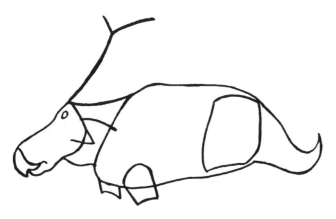

3. Complete its neck and tail, and sketch its hip. Begin to form its head frill and front legs.

4. Sketch its nostril, and further render its head frill and legs. Add the horns on its forehead and snout.

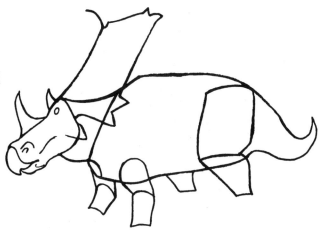

5. Draw more of its head frill, and further detail its mouth. Add its feet, one more small horn, and some muscle definition. Erase any unneeded lines.

6. Define its toes, and then finish its head frill. Refine your overall drawing, adding wrinkles as shown. Erase additional unneeded lines.

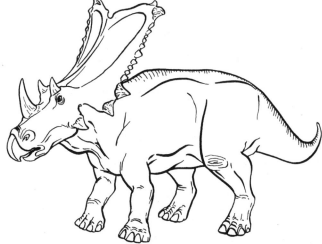

Edmontosaurus

SCIENTISTS BELIEVE THE EDMONTOSAURUS COULD, FOR SHORT PERIODS, RUN AS FAST AS 9 TO 12 MILES (14 TO 19 KM) PER HOUR.

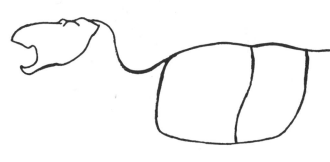

1. Begin by outlining the Edmontosaurus's head, body, and hip. Also create the top of its neck and tail.

2. Complete its neck and tail. Sketch its kneecap, as well as some facial features and muscle definition.

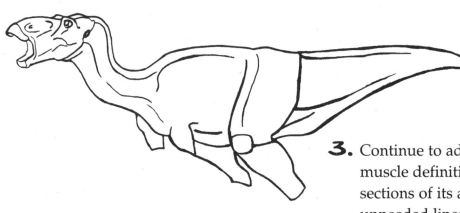

3. Continue to add facial detail and muscle definition. Render the upper sections of its arms and legs. Erase unneeded lines.

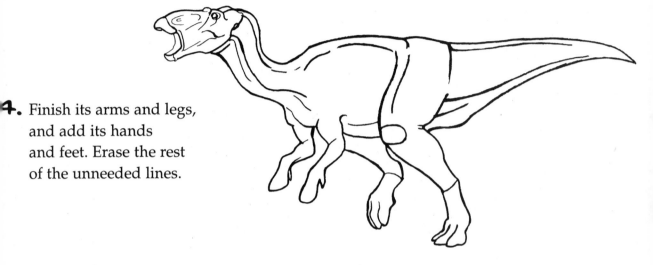

4. Finish its arms and legs, and add its hands and feet. Erase the rest of the unneeded lines.

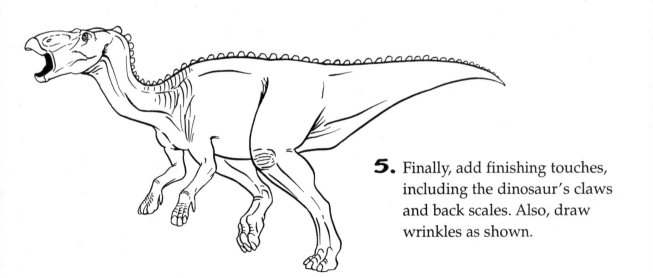

5. Finally, add finishing touches, including the dinosaur's claws and back scales. Also, draw wrinkles as shown.

Triceratops

TRICERATOPS WAS A HUGE, MUSCULAR ANIMAL WITH THREE SHARP HORNS ON ITS HEAD AND AN ARMORED HEAD FRILL OF BONE.

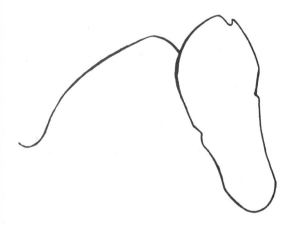

1. Outline the Triceratops's head, and attach the top of its back and tail.

2. Add its body and hip. Create the line down its head that defines its large head frill. Draw facial features.

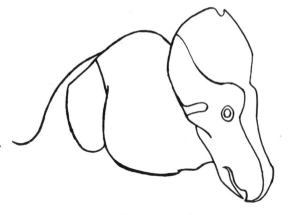

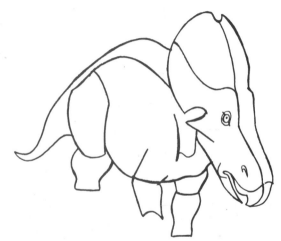

3. Further define its head frill and facial features. Complete its tail, and begin to sketch its neck and legs as shown.

4. Draw more of its legs, muscle definition, and the three ovals where its horns will sit. Add detail to its head frill.

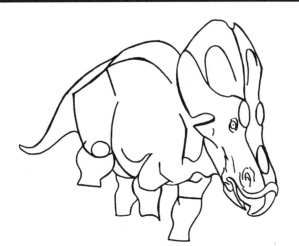

5. Now attach its pointed horns, as well as its four feet. Refine the shape of its legs, erasing any unneeded lines.

6. Finally, add the pointed edges to this dinosaur's head frill. Render its toenails, and erase any additional unneeded lines. Then shade as shown.

Kentrosaurus

THE KENTROSAURUS, A SMALL MEMBER OF THE STEGOSAUR FAMILY, LIVED 140 MILLION YEARS AGO IN WHAT IS TODAY'S TANZANIA.

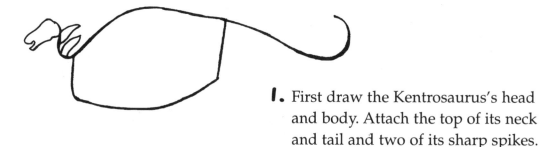

1. First draw the Kentrosaurus's head and body. Attach the top of its neck and tail and two of its sharp spikes.

2. Outline its hip. Then sketch the rest of its neck and tail, as well as some facial features. Continue to add spikes, and begin to create one of its legs.

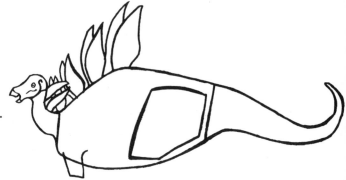

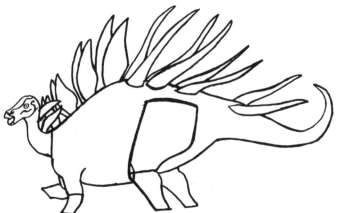

3. Attach more spikes, and further form its legs. Also, add more facial detail.

4. Draw more spikes, and refine its hip. Add its feet, and then erase any unneeded lines.

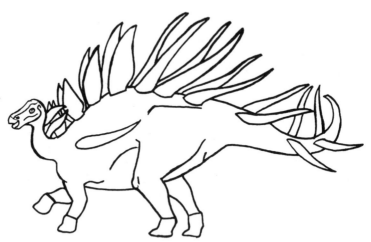

5. Finally, sketch the two large spikes at the end of its tail. Then shade and add detail as shown. Erase additional unneeded lines.

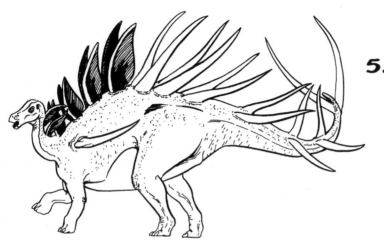

THE PARASAUROLOPHUS WAS A BEAUTIFUL DUCKBILL DINOSAUR. THE CURVING CREST ON ITS HEAD PROBABLY HELPED IT PRODUCE LOW, DISTINCTIVE SOUNDS.

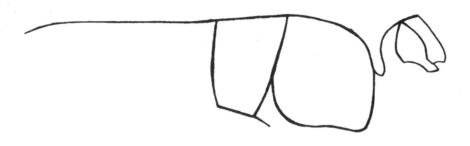

1. To begin, create the Parasaurolophus's head, body, and hip. Draw the top of its neck and tail.

2. Create the outline of its head crest, and then add detail to the crest and to the dinosaur's face. Complete its neck and tail, and draw the line running along its body.

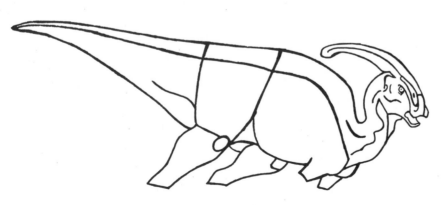

3. Erase the dividing line of its neck. Begin to form its legs, including kneecaps. Add muscle definition to its neck.

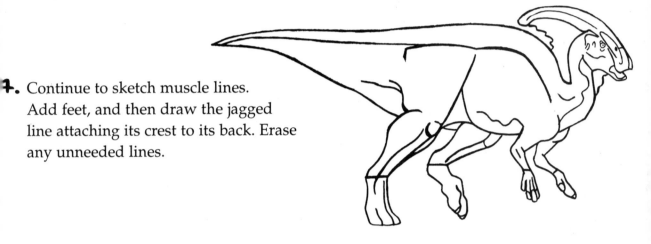

4. Continue to sketch muscle lines. Add feet, and then draw the jagged line attaching its crest to its back. Erase any unneeded lines.

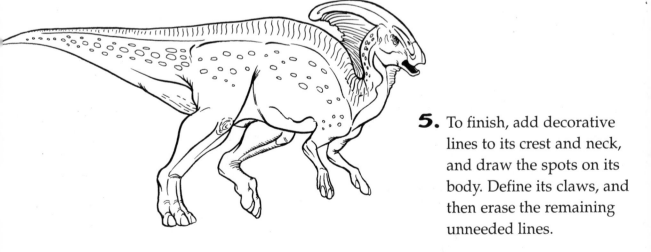

5. To finish, add decorative lines to its crest and neck, and draw the spots on its body. Define its claws, and then erase the remaining unneeded lines.

Maiasaura

FOSSILS HAVE REVEALED THAT THE MAIASAURA TOOK CARE OF ITS BABIES LONG AFTER THEY HATCHED FROM THEIR EGGS.

1. Sketch the dinosaur's head and body, as well as the top of its neck and back.

2. Complete its neck and tail, and begin to define its legs. Also, add facial features.

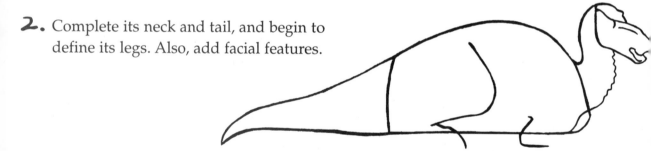

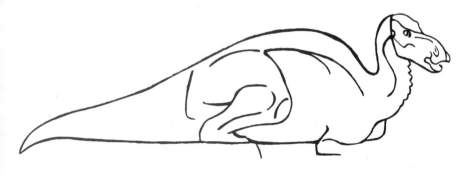

3. Further form its legs. Add more facial features, as well as muscle lines where indicated.

4. Finish outlining its legs, and then
define the ridge on top of its head.
Erase any unneeded lines.

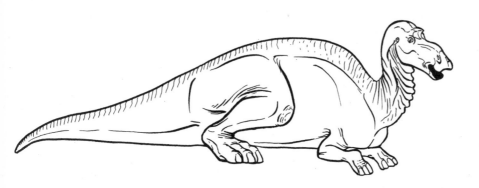

5. To complete your Maiasaura, refine the head ridge,
and sketch the ridges along its neck. Draw wrinkles
where shown, and add its claws.

Corythosaurus

THE ROUND CREST ON TOP OF THIS DUCKBILL DINOSAUR'S HEAD MAY HAVE HELPED IT PRODUCE MANY UNIQUE SOUNDS.

1. First outline its head and mouth. To its right, attach the top of its back and tail. To its left, attach part of its neck.

2. Complete its body and tail. Sketch its eye and the curved line on its forehead.

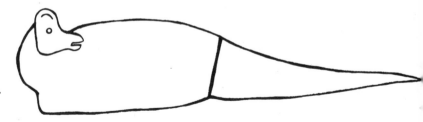

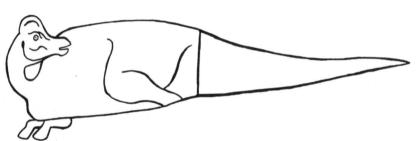

3. Add more facial features, and begin to create its legs. Further define its neck with the circular shape below its head.

4. Draw its kneecap and two back feet. Add more
facial features and muscle definition along its back.
Erase the line between its body and tail.

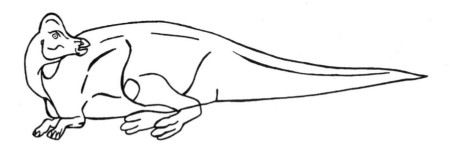

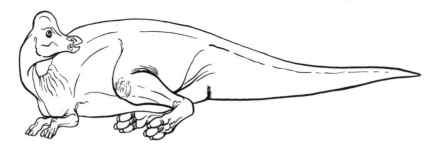

5. Complete your dinosaur by adding
detail to its legs and feet. Also add
the wrinkles on its body and neck.

Brachiosaurus

THIS GIANT DINOSAUR MAY HAVE BEEN 46 FEET (14 M) TALL, 73 FEET (22 M) LONG, AND COULD HAVE WEIGHED UP TO 160,000 POUNDS (72,000 KG).

1. Sketch the Brachiosaurus's body, hip, and head. Attach the top of its long neck and tail.

2. Add facial detail, and complete its neck and tail. Begin to form its legs as shown.

3. Render muscle definition on its neck and body, and complete two of its legs.

4. Add its eye pupil and more muscle lines. Create its other two legs, and erase unneeded lines.

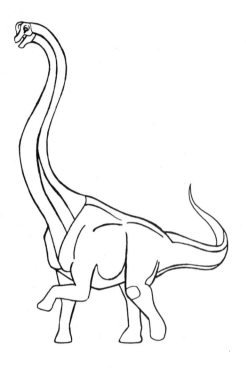

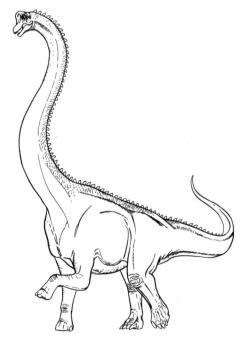

5. Draw its spikes, and detail its legs and feet as shown. Also, add wrinkles as shown. Erase any other unneeded lines.

Ankylosaurus

THE ANKYLOSAURUS USED THE HEAVY CLUB AT THE END OF ITS TAIL TO DEFEND ITSELF AGAINST ENEMIES.

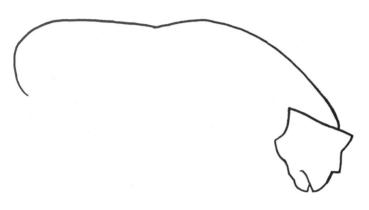

I. Draw the top of the Ankylosaurus's neck, back, and tail, and outline its head.

2. Complete its body and tail, and insert the outline of its hip. Begin to detail its face as shown.

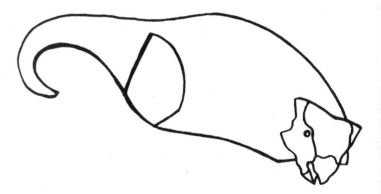

3. Add more detail to its face. Sketch its tail club and the lines that define the underside of its body and tail. Begin to form its legs.

4. Form the lower leg
sections, and add
detail to its tail club.
Begin to render the
scales on its back plate.

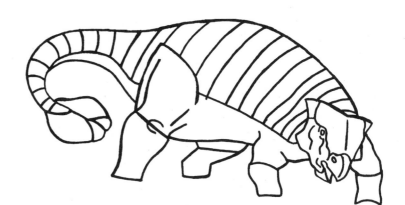

5. Draw its feet, and erase
unneeded lines. Continue
to define the heavy plates
on its back and tail.

6. To finish your dinosaur,
complete rendering the
heavy plates, and then
shade as shown. Erase
additional unneeded lines.

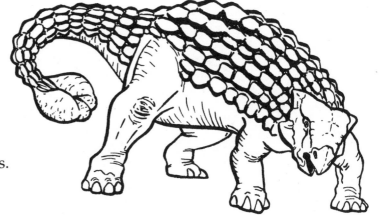

Edmontonia

THIS WELL-PROTECTED DINOSAUR HAD ARMOR PLATING ON ITS BACK AND LARGE, SHARP SPIKES GROWING OUT OF ITS SIDES.

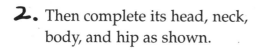

1. First draw the top portion of the Edmontonia's neck, body, and tail.

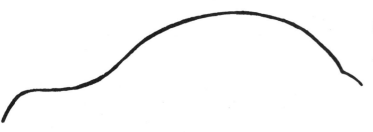

2. Then complete its head, neck, body, and hip as shown.

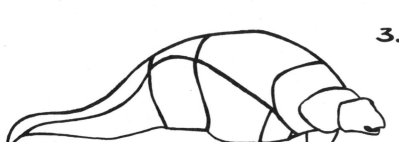

3. Sketch the rest of its tail and the lines outlining the plate on its back. Start to form its front legs.

4. Create its bottom leg sections. Draw some facial features and the spikes along the side of its plate.

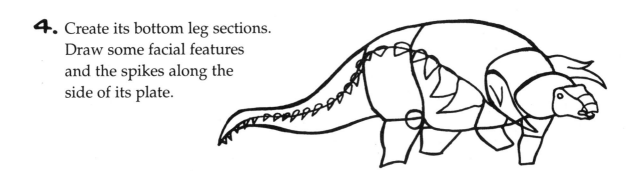

5. Begin to define the top of the plate, and draw more spikes. Further detail its face. Add feet, and erase any unneeded lines.

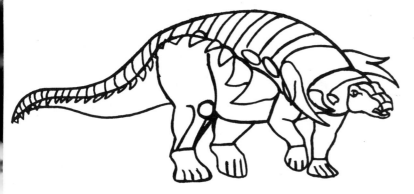

6. Draw the remaining detail on the Edmontonia's back plate, and then refine its feet. Erase any other unneeded lines.

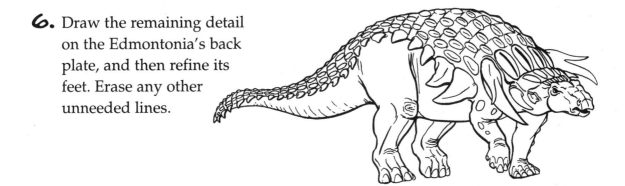

Centrosaurus

CENTROSAURUSES ROAMED THE LAND IN LARGE GROUPS CALLED HERDS, WHICH HELPED PROTECT THEM FROM MEAT-EATING PREDATORS

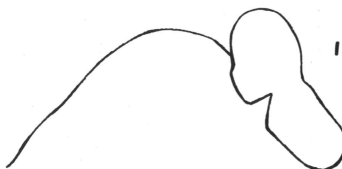

1. Sketch the Centrosaurus's head, and attach the top of its back and tail.

2. Add its eye, nostril, mouth, and horn. Create its body with hip.

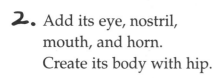

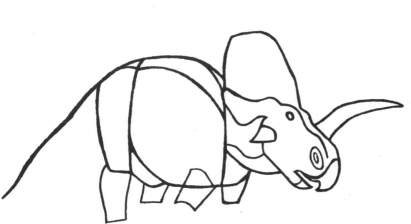

3. Further detail its face, and define its head crest, neck, and back. Begin to form its legs, and attach the spike on the side of its face.

4. Complete its tail and legs. Sketch muscle definition where indicated. Erase unneeded lines.

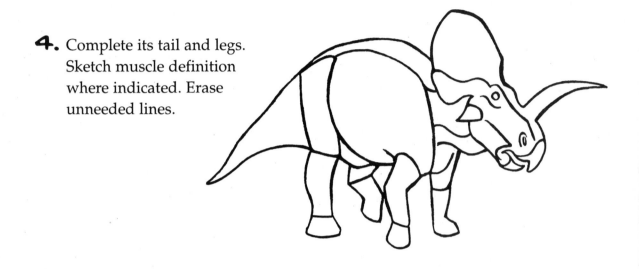

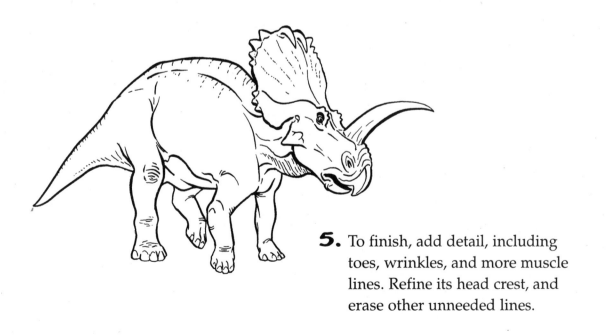

5. To finish, add detail, including toes, wrinkles, and more muscle lines. Refine its head crest, and erase other unneeded lines.

Einiosaurus

THE EINIOSAURUS, WHOSE NAME MEANS "BUFFALO LIZARD," IS ONE OF THE MOST RECENTLY DISCOVERED HORNED DINOSAURS.

1. Outline its head, and draw the top of its back and tail.

2. Begin to define its head crest, and insert facial features. Sketch its body and hip.

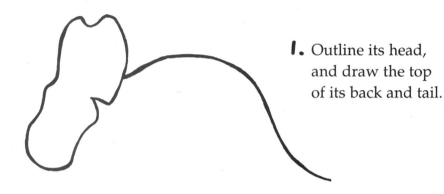

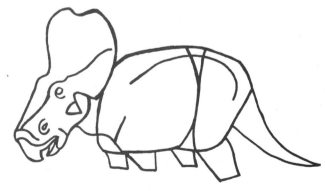

3. Complete its neck and tail, and add more facial detail, including the spike on its cheek. Begin to form its legs.

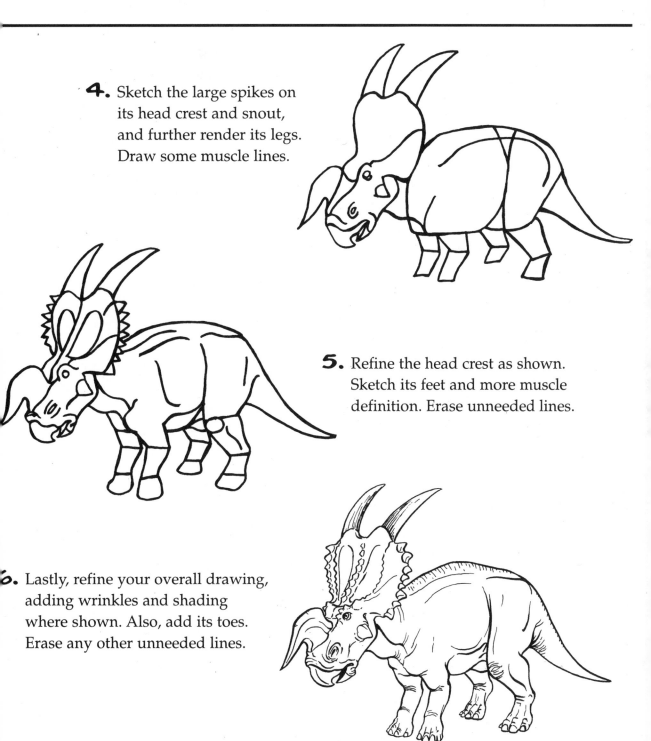

4. Sketch the large spikes on its head crest and snout, and further render its legs. Draw some muscle lines.

5. Refine the head crest as shown. Sketch its feet and more muscle definition. Erase unneeded lines.

6. Lastly, refine your overall drawing, adding wrinkles and shading where shown. Also, add its toes. Erase any other unneeded lines.

Leptoceratops

ONE OF THE SMALLEST MEMBERS OF THE HORNED DINOSAUR FAMILY LEPTOCERATOPS WAS ONLY ABOUT AS BIG AS A LARGE DOG!

1. Draw this dinosaur's head, complete with jaw line. Then create the top of its neck, back, and tail.

2. Outline its neck, body, and hip, and sketch the line that defines its horned head.

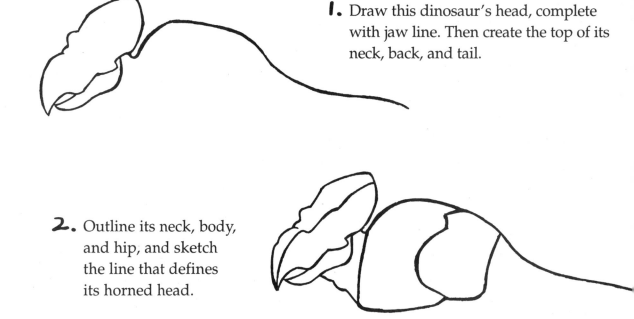

3. Add more lines defining the shape of its head. Complete its tail, and begin to create its upper legs as shown.

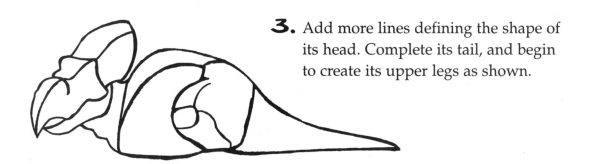

4. Continue to render its legs, and add some facial features. Depict the wrinkles in its skin behind its back leg.

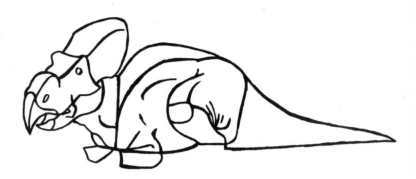

5. Sketch the wrinkles behind its neck. Add its feet and more detail to its face. Erase unneeded lines.

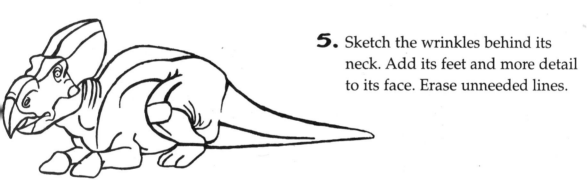

6. Finally, refine the Leptoceratops's legs and feet, and add additional wrinkles where shown. Erase other unneeded lines.

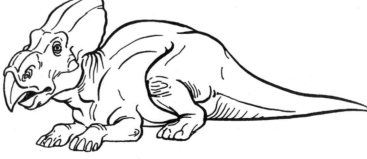

Styracosaurus

SCIENTISTS BELIEVE THAT HERBIVORES SUCH AS THE STYRACOSAURUS TRAVELED IN LARGE HERDS FOR SAFETY.

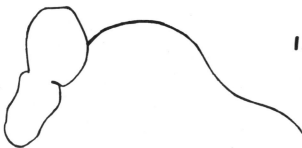

1. To begin, create the outline of the Styracosaurus's head. Also, draw the top of its back and tail.

2. Complete its body, and start to define its head frill.

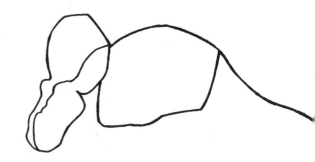

3. Sketch its hip, begin to form its front legs, and add some facial features. Complete its neck and tail, and refine its frill.

4. Draw the circular shapes within its head frill, and form its mouth. Continue to render its legs. Erase the unneeded neck line.

5. Begin to form the spikes around its head frill and on its snout. Attach its feet, and add muscle definition and more facial detail. Erase unneeded lines.

6. Finish the head frill and snout as shown. Draw the wrinkles and spots on its body. Then refine the overall body shape, erasing any unneeded lines.

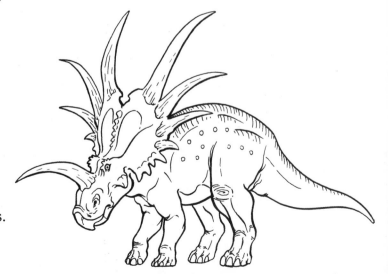

Allosaurus

ALLOSAURUS WAS A POWERFUL MEAT-EATING PREDATOR THAT DOMINATED THE EARTH LONG BEFORE TYRANNOSAURUS REX LIVED.

I. Draw the outline of the Allosaurus's head, body, and hip. Attach the top of its neck and tail.

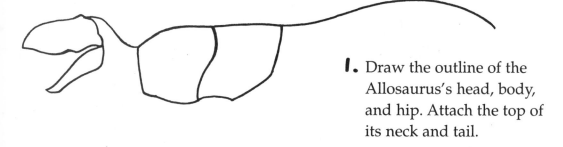

2. Begin to add its arms and legs, and finish its neck and tail. Add facial features, including the two small horns atop its head.

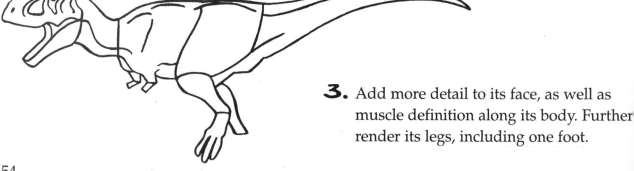

3. Add more detail to its face, as well as muscle definition along its body. Further render its legs, including one foot.

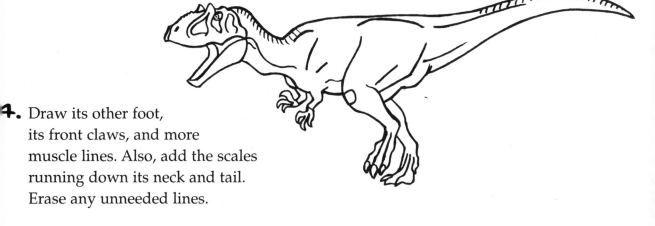

4. Draw its other foot, its front claws, and more muscle lines. Also, add the scales running down its neck and tail. Erase any unneeded lines.

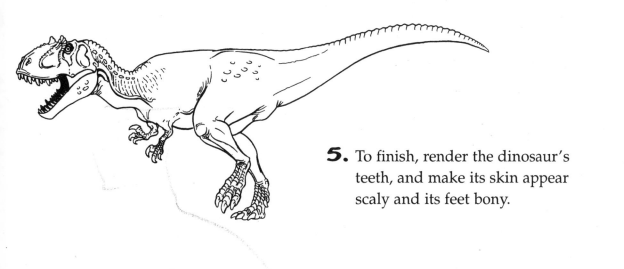

5. To finish, render the dinosaur's teeth, and make its skin appear scaly and its feet bony.

CERATOSAURUS WAS A SPEEDY DINOSAUR WITH A LARGE, BROAD TAIL, WHICH MAY HAVE BEEN USED FOR SWIMMING.

1. Begin by sketching its head, as well as the top of its neck, body, and tail.

2. Draw the rest of its body with the hip. Form its eye, nostril, and large horn.

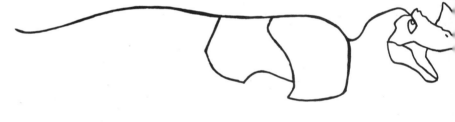

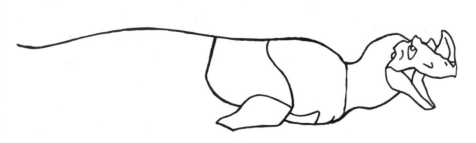

3. Complete its neck, and begin to render its legs. Add more detail to its head.

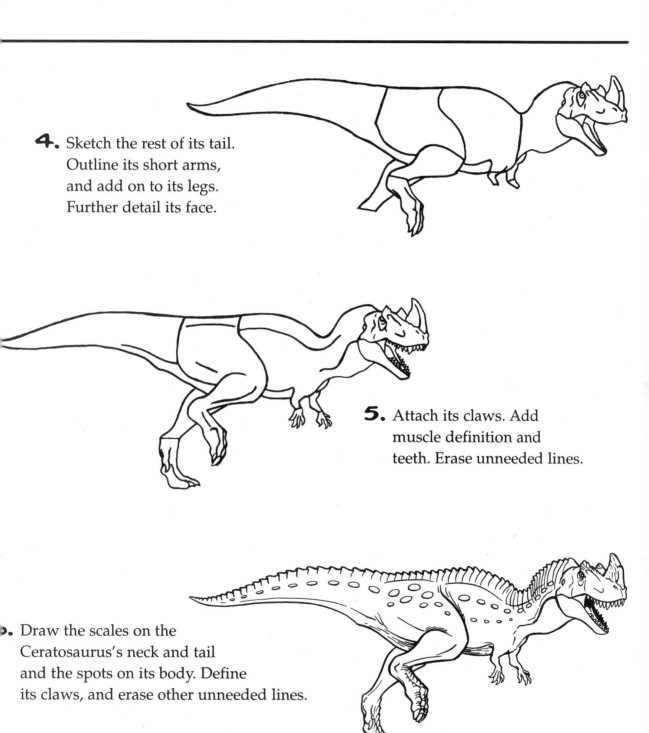

4. Sketch the rest of its tail. Outline its short arms, and add on to its legs. Further detail its face.

5. Attach its claws. Add muscle definition and teeth. Erase unneeded lines.

. Draw the scales on the Ceratosaurus's neck and tail and the spots on its body. Define its claws, and erase other unneeded lines.

ACROCANTHOSAURUS WAS A CLOSE RELATIVE OF THE ALLOSAURUS. THE SAIL ON ITS BACK IS THOUGHT TO HAVE RELEASED HEAT, HELPING IT COOL DOWN IN HOT WEATHER.

1. Outline the Acrocanthosaurus's head, body, and hip. Attach a neck and tail line.

2. Draw its sail, and the ridges on top of its head. Insert its eye, and begin to form its arms.

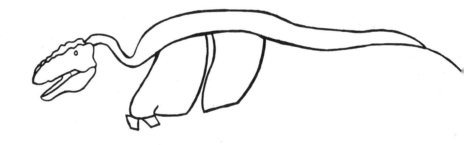

3. Further detail its face, and attach its hip. Outline its legs, adding one visible knee.

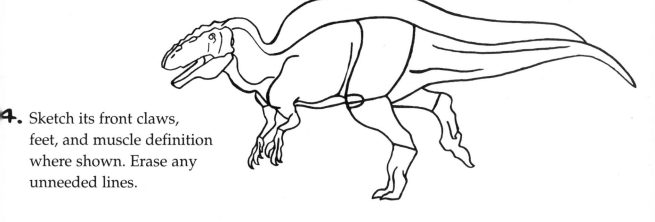

4. Sketch its front claws, feet, and muscle definition where shown. Erase any unneeded lines.

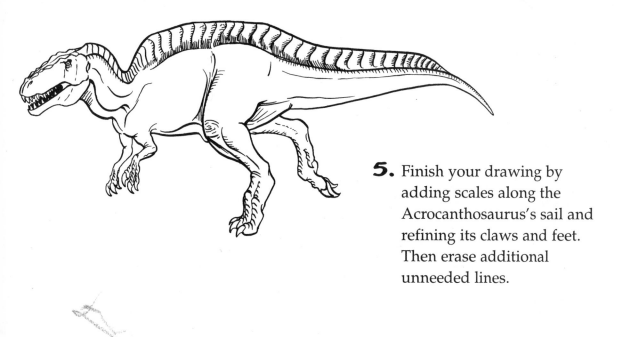

5. Finish your drawing by adding scales along the Acrocanthosaurus's sail and refining its claws and feet. Then erase additional unneeded lines.

THIS FIERCE, CARNIVOROUS PREDATOR HAD A SLIGHT HUMPBACK AND A UNIQUE HEAD DECORATED WITH SCALY RIDGES.

1. To start your Metriacanthosaurus, sketch the outline of its head, body, and hip. Attach neck and tail lines.

2. Insert its visible nostril and eye. Complete its neck and tail. Begin to create its arms.

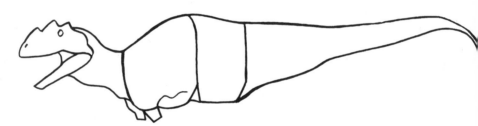

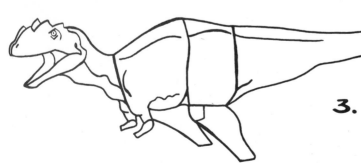

3. Sketch another ridge on its head, more of its legs, and some muscle definition. Add more facial detail.

4. Add its front and
back claws and
another head ridge.
Erase any unneeded lines.

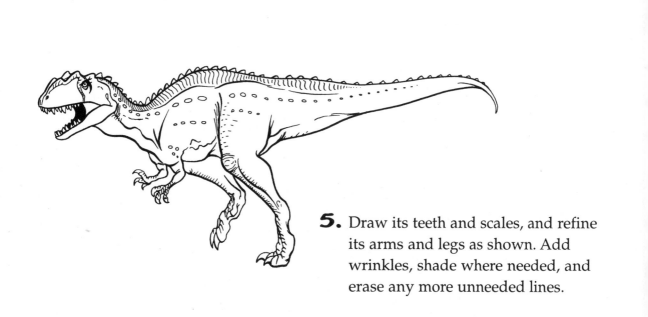

5. Draw its teeth and scales, and refine
its arms and legs as shown. Add
wrinkles, shade where needed, and
erase any more unneeded lines.

Deinonychus

DEINONYCHUS FOSSILS HAVE SHOWN THAT THIS FIERCE DINOSAUR PROBABLY HUNTED IN PACKS, SIMILAR TO TODAY'S WOLVES.

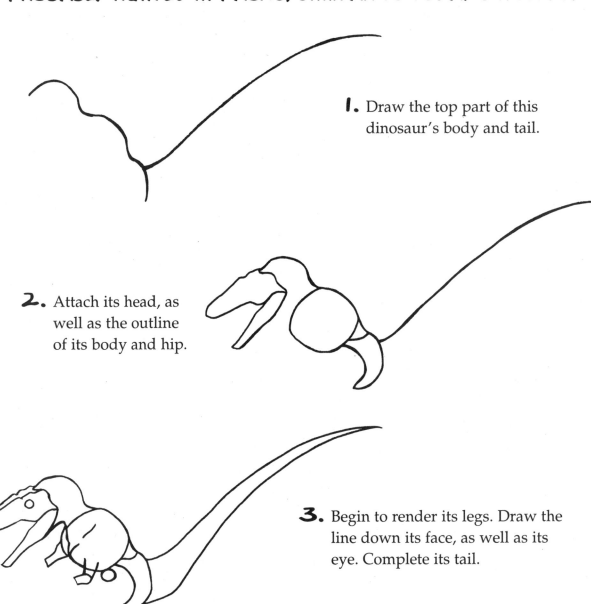

1. Draw the top part of this dinosaur's body and tail.

2. Attach its head, as well as the outline of its body and hip.

3. Begin to render its legs. Draw the line down its face, as well as its eye. Complete its tail.

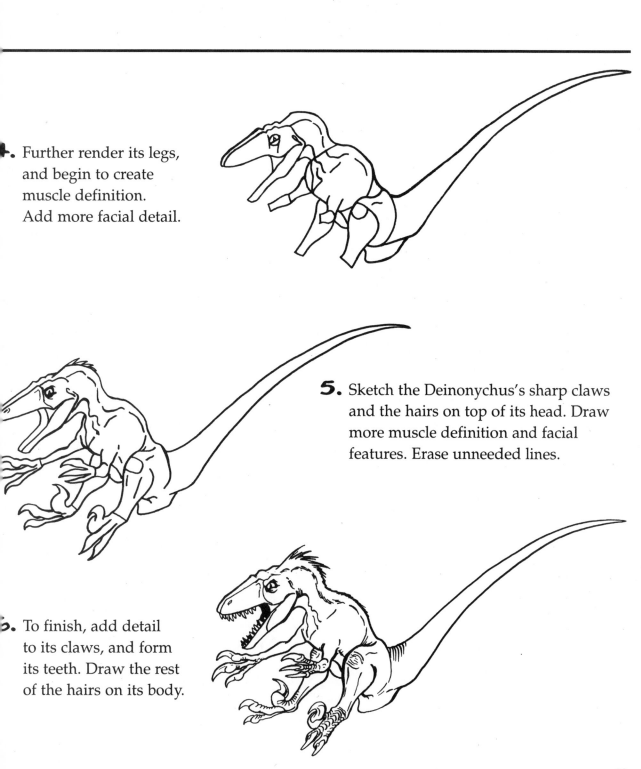

4. Further render its legs, and begin to create muscle definition. Add more facial detail.

5. Sketch the Deinonychus's sharp claws and the hairs on top of its head. Draw more muscle definition and facial features. Erase unneeded lines.

6. To finish, add detail to its claws, and form its teeth. Draw the rest of the hairs on its body.

Velociraptor

THE VELOCIRAPTOR WAS A SMALLER BUT EQUALLY FEROCIOUS RELATIVE OF THE DEINONYCHUS.

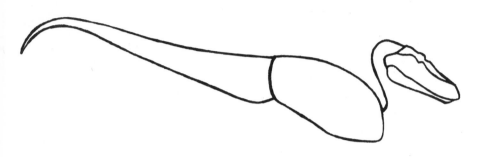

1. Begin by outlining the Velociraptor's head, body, and tail. Attach its curved neck line.

2. Add facial detail, and begin to form its hip and its arm.

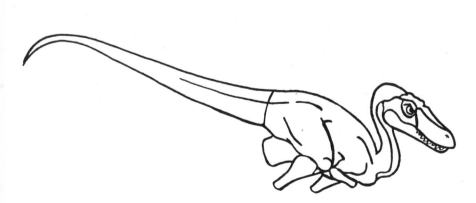

3. Further render its legs. Sketch its teeth and some muscle definition.

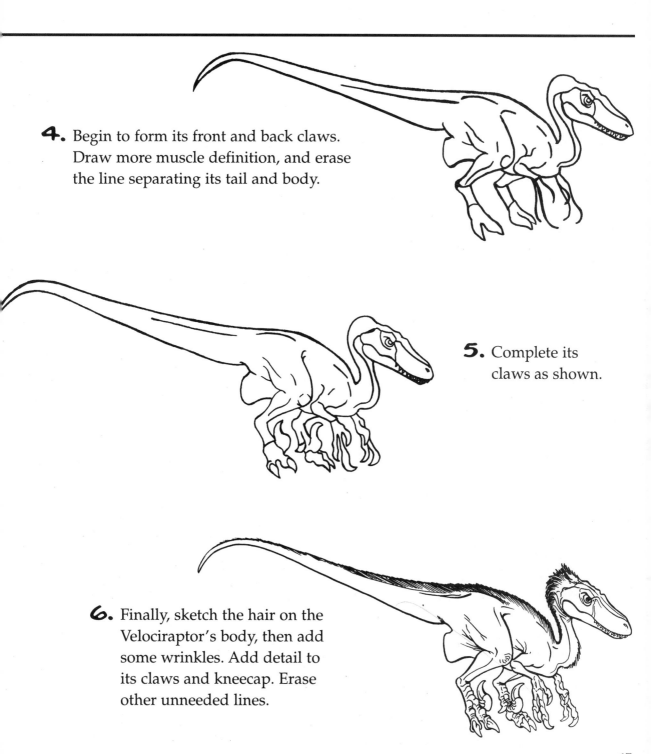

4. Begin to form its front and back claws. Draw more muscle definition, and erase the line separating its tail and body.

5. Complete its claws as shown.

6. Finally, sketch the hair on the Velociraptor's body, then add some wrinkles. Add detail to its claws and kneecap. Erase other unneeded lines.

Utahraptor

THE LARGEST RAPTOR CLAW FOUND IN NORTH AMERICA BELONGS TO THE VICIOUS UTAHRAPTOR, A RELATIVE OF THE VELOCIRAPTOR.

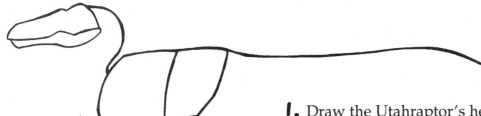

1. Draw the Utahraptor's head, body, and hip. Attach the top of its neck and tail.

2. Begin forming one of its arms, and complete its neck and tail. Add some facial detail.

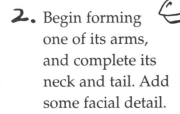

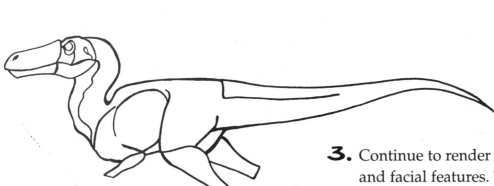

3. Continue to render its arms, legs, and facial features. Then sketch some muscle definition. Erase unneeded lines

4. Add the spikes on the Utahraptor's head and the wrinkles on its head and neck. Attach its hands and feet, and further define its muscles.

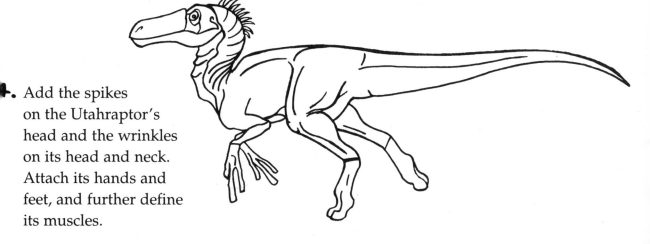

5. Finally, draw its teeth and hair. Refine its hands and feet, and then add finishing detail as shown.

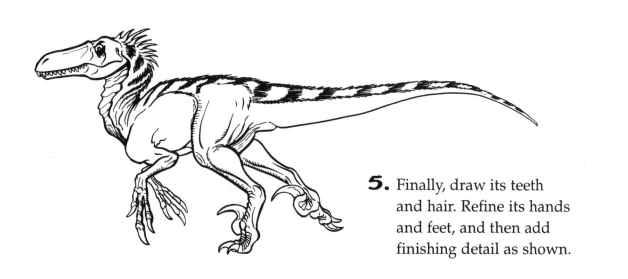

Eoraptor

SCIENTISTS BELIEVE THAT THE TINY EORAPTOR, WHOSE NAME MEANS "DAWN HUNTER," MAY HAVE BEEN ONE OF THE EARLIEST LIVING DINOSAURS.

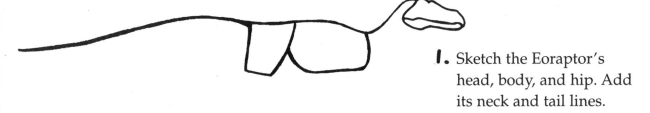

1. Sketch the Eoraptor's head, body, and hip. Add its neck and tail lines.

2. Sketch its mouth, nostril, and eye, and then complete its neck and tail. Begin to render its arms and legs.

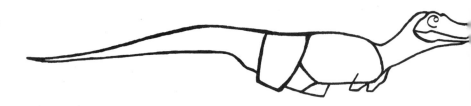

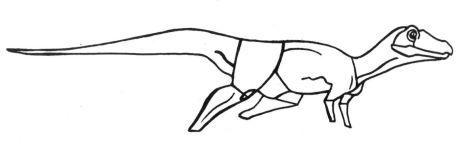

3. Further form its arms and legs, and add some muscle definition.

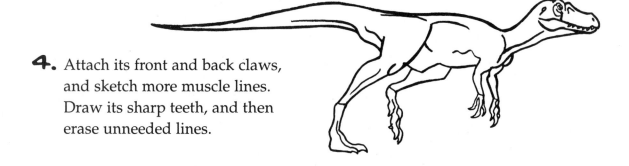

4. Attach its front and back claws, and sketch more muscle lines. Draw its sharp teeth, and then erase unneeded lines.

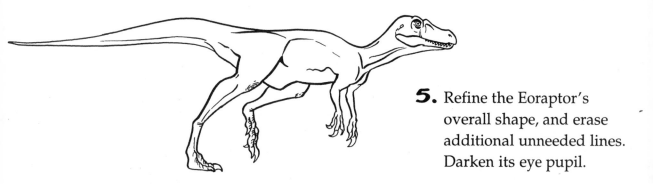

5. Refine the Eoraptor's overall shape, and erase additional unneeded lines. Darken its eye pupil.

Troodon

THE TROODON'S BRAIN WAS FAR LARGER—COMPARED TO ITS BODY WEIGHT—THAN THAT OF ANY OTHER DINOSAUR.

1. Sketch the Troodon's body and head, as well as its neck and tail lines.

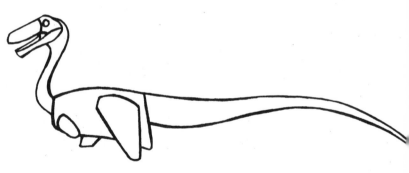

2. Draw its eye, and begin to form its arms and legs. Complete its neck and tail.

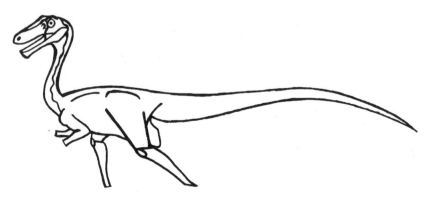

3. Continue to draw its arms and legs, and add facial detail. Sketch the wavy line on its neck, and erase unneeded lines.

4. Draw its teeth, muscle definition, and its front and back claws. Erase more unneeded lines.

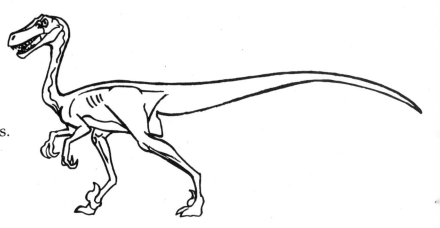

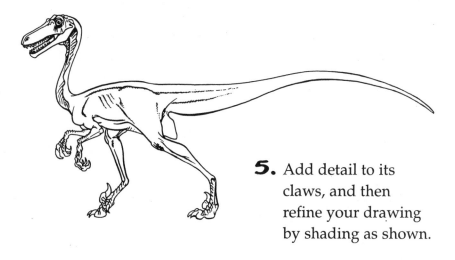

5. Add detail to its claws, and then refine your drawing by shading as shown.

37

Spinosaurus

THE SPINOSAURUS HAD A LARGER SAIL ON ITS BACK
THAN ANY OTHER CARNIVOROUS DINOSAUR.

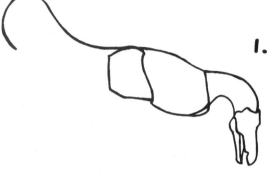

1. Render the dinosaur's head, neck, body,
and hip. Then attach the top of its tail.

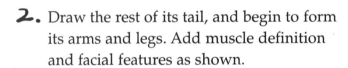

2. Draw the rest of its tail, and begin to form
its arms and legs. Add muscle definition
and facial features as shown.

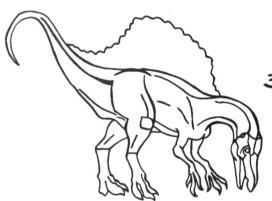

3. Create the next section of its arms and legs,
and sketch more muscle lines. Outline its back
sail, and draw its claws. Erase unneeded lines.

4. Refine its claws, and add
scales to its sail. Draw
its eye pupil and teeth.
Erase other unneeded lines.

Gallimimus

GALLIMIMUS'S MUSCULAR LEGS AND SLENDER, OSTRICHLIKE BODY
SHAPE WERE IDEAL FOR SWIFT RUNNING.

1. Outline the Gallimimus's
face, body, and hip. Attach
the back of its neck and tail.

2. Render its mouth and eye, and begin to form
its arms and legs. Complete its neck and tail.

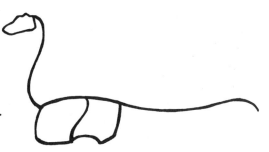

3. Further form its arms
and legs, adding hands
and feet. Define the
bump on top of its head,
and add muscle definition.
Erase unneeded lines.

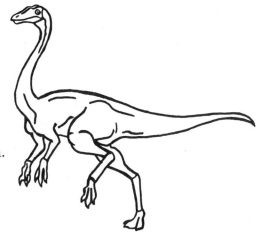

4. Complete your dinosaur by adding
detail to its body and claws as shown.
Erase any other unneeded lines.

THE TYRANNOSAURUS REX, WHOSE NAME MEANS "KING OF THE TYRANT LIZARDS," IS KNOWN AS ONE OF THE MOST POWERFUL LAND PREDATORS THAT EVER LIVED.

1. Render the T-Rex's head and its back and tail lines.

2. Draw its body and hip.

3. Add facial features, and complete its neck and tail. Begin to form its arms and legs.

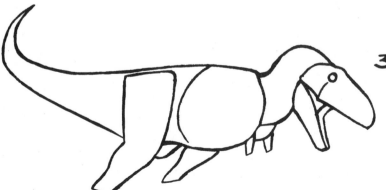

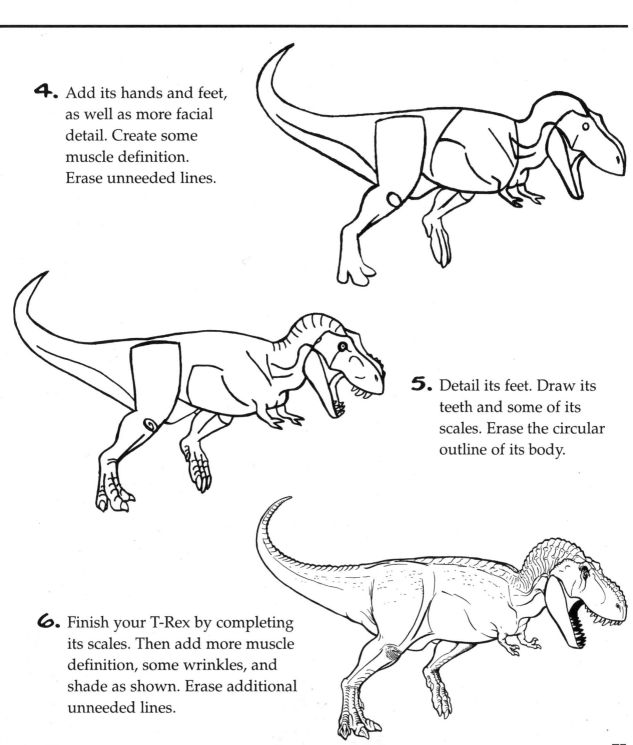

4. Add its hands and feet, as well as more facial detail. Create some muscle definition. Erase unneeded lines.

5. Detail its feet. Draw its teeth and some of its scales. Erase the circular outline of its body.

6. Finish your T-Rex by completing its scales. Then add more muscle definition, some wrinkles, and shade as shown. Erase additional unneeded lines.

Dilophosaurus

THE DECORATIVE HEAD CRESTS OF THE DILOPHOSAURUS MAY HAVE BEEN BRIGHTLY COLORED TO ATTRACT MATES.

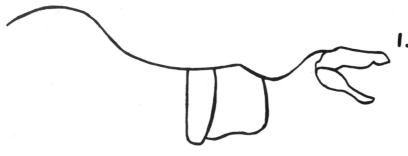

1. Draw the head, body, and hip of the Dilophosaurus. Attach the top of its neck and tail.

2. Sketch its two head crests and its eye and nostril. Begin its arms and one leg, and complete its neck and tail.

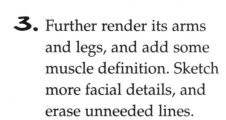

3. Further render its arms and legs, and add some muscle definition. Sketch more facial details, and erase unneeded lines.

4. Attach the Dilophosaurus's
front claws, and erase
additional unneeded lines.
Add more muscle lines.

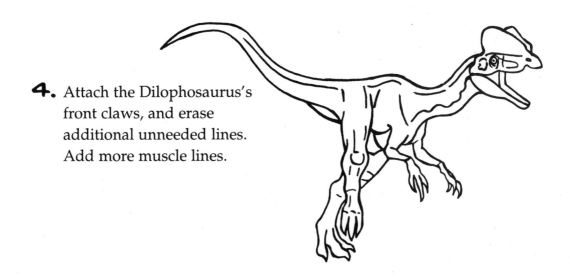

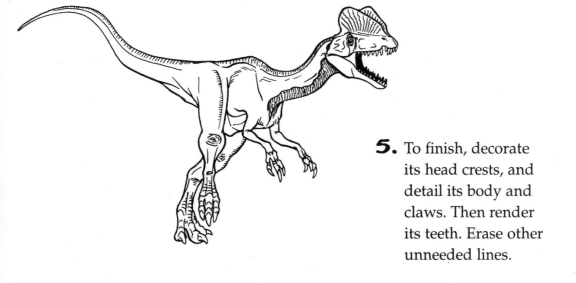

5. To finish, decorate
its head crests, and
detail its body and
claws. Then render
its teeth. Erase other
unneeded lines.

Baryonyx

THIS LAND-DWELLING DINOSAUR MAY HAVE LOOKED LIKE A CROCODILE, BUT IT LIVED MORE LIKE A GRIZZLY BEAR—IN FORESTED LAND.

1. Sketch its head and the top of its neck, body, and tail.

2. Complete its neck, body, and hip. Draw its eye.

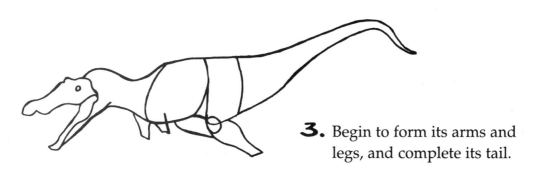

3. Begin to form its arms and legs, and complete its tail.

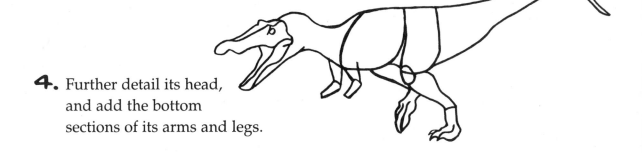

4. Further detail its head, and add the bottom sections of its arms and legs.

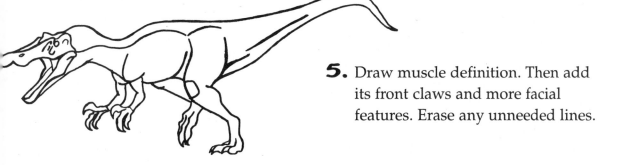

5. Draw muscle definition. Then add its front claws and more facial features. Erase any unneeded lines.

6. Draw its teeth and the scales along its head, neck, and back. Detail its claws, and shade as shown.

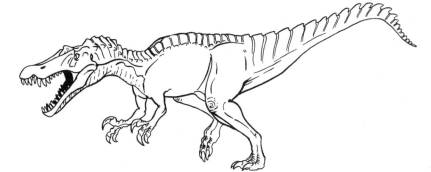

Compsognathus

 1

THE COMPSOGNATHUS, THE TINIEST ADULT DINOSAUR FOUND TO DATE, WAS NO BIGGER THAN A MODERN-DAY BIRD.

1. Render its head, body, and hip. Add its neck and tail lines.

2. Add the small bump on top of its head, and sketch some facial features. Complete its neck and tail.

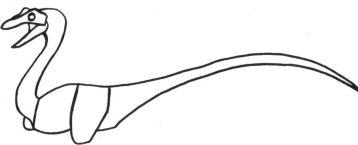

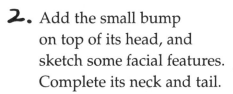

3. Draw more facial features, and start to form its arms and legs. Create muscle definition. Then erase unneeded lines.

4. Add its lower arm sections, the wrinkles on the base of its neck, and more facial detail. Also, attach its feet. Erase other unneeded lines.

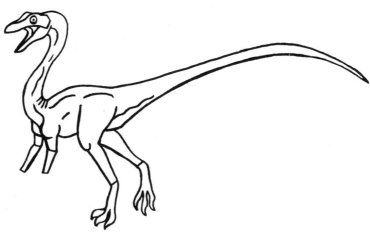

5. Sketch its front claws and teeth.

6. Refine the legs and claws, then erase any additional unneeded lines.

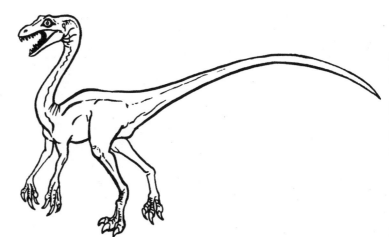

Coelophysis

THE COELOPHYSIS WAS A SMALL BUT VICIOUS CARNIVORE THAT, ON OCCASION, EVEN ATE ITS OWN YOUNG.

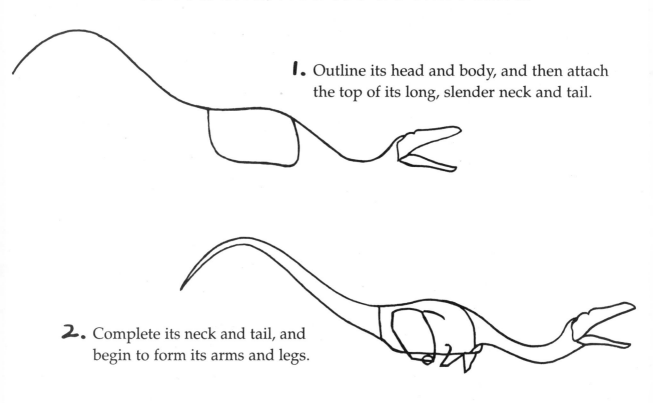

1. Outline its head and body, and then attach the top of its long, slender neck and tail.

2. Complete its neck and tail, and begin to form its arms and legs.

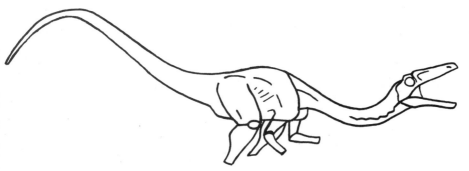

3. Sketch some facial features and the lower section of its arms and legs. Add muscle definition, and erase the line between its body and tail.

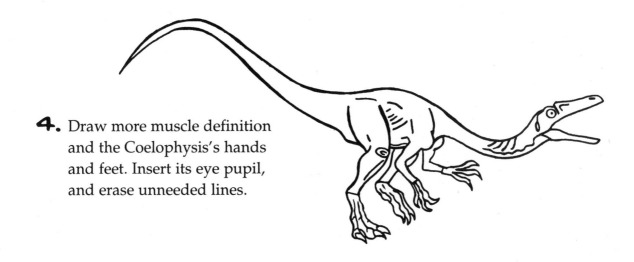

4. Draw more muscle definition and the Coelophysis's hands and feet. Insert its eye pupil, and erase unneeded lines.

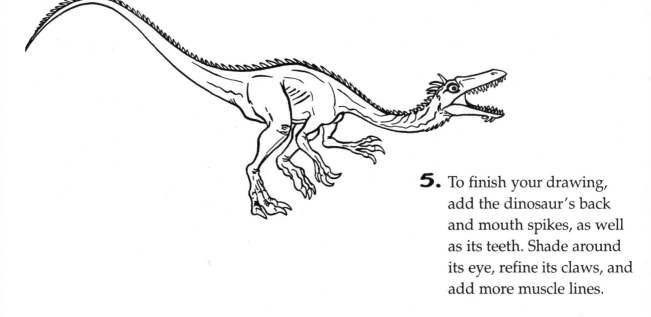

5. To finish your drawing, add the dinosaur's back and mouth spikes, as well as its teeth. Shade around its eye, refine its claws, and add more muscle lines.

THIS FAST-MOVING DINOSAUR IS BELIEVED TO HAVE EATEN EGGS, INSECTS, SMALL LIZARDS, AND RODENTS.

1. To begin, render this dinosaur's head, body, and hip. Also, draw its neck and tail lines.

2. Add its eye and nostril and the top section of its arms. Draw the rest of its neck and tail.

3. Begin to create its legs and the muscle definition on its neck and back. Further render its arms, and draw its eye pupil.

4. Add its hands and feet and more muscle definition. Then erase any unneeded lines.

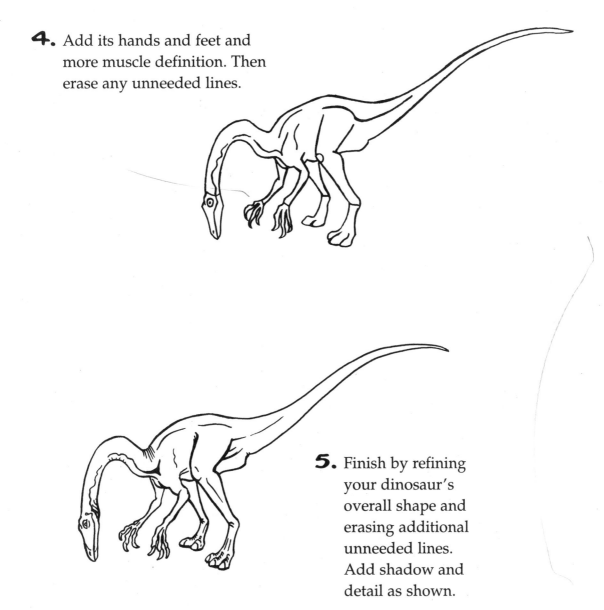

5. Finish by refining your dinosaur's overall shape and erasing additional unneeded lines. Add shadow and detail as shown.

Chirostenotes

SCIENTISTS BELIEVE THAT THE LONG FRONT CLAWS OF THE CHIROSTENOTES MAY HAVE BEEN USEFUL FOR BOTH GROOMING AND CATCHING SMALL PREY.

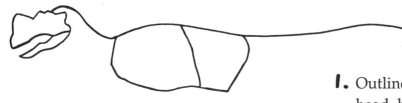

1. Outline this dinosaur's head, body, and hip. Attach its neck and tail lines.

2. Begin to detail its face. Complete its neck and tail, and start to create its arms. Draw the wavy line down its neck.

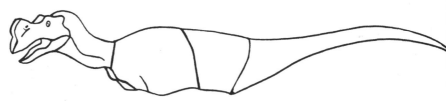

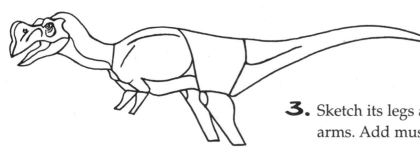

3. Sketch its legs and the lower section of its arms. Add muscle definition and facial detail.

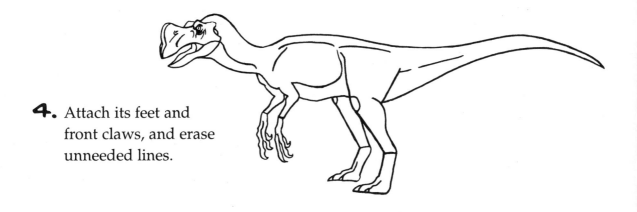

4. Attach its feet and front claws, and erase unneeded lines.

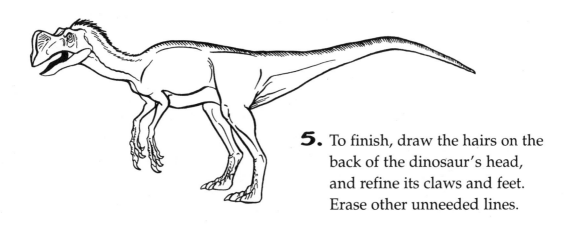

5. To finish, draw the hairs on the back of the dinosaur's head, and refine its claws and feet. Erase other unneeded lines.

Albertosaurus

ALBERTOSAURUS WAS A SMALL, FAST, AND SLEEK RELATIVE OF THE FIERCE TYRANNOSAURUS REX.

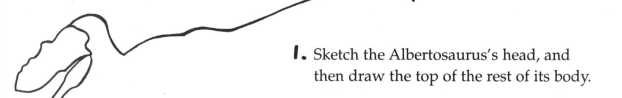

1. Sketch the Albertosaurus's head, and then draw the top of the rest of its body.

2. Begin to detail its face, and complete its body and tail. Outline its hip.

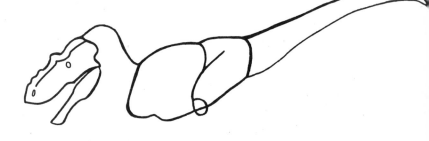

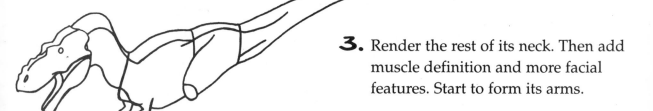

3. Render the rest of its neck. Then add muscle definition and more facial features. Start to form its arms.

4. Add the lower section of its arms. Create more muscle lines and facial detail. Begin to form its legs, and erase any unneeded lines.

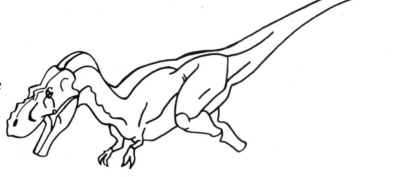

5. Sketch the wrinkles on its nose and the scales on its neck and back. Attach its front and back claws.

6. To finish, further render the Albertosaurus's scales and claws. Draw its teeth, and add shading as shown.

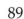

BELIEVE IT OR NOT, THIS DINOSAUR'S SKELETON WAS FOUND IN ICY ANTARCTICA!

I. Sketch your Cryolophosaurus's head, and draw the top of the rest of its body.

2. Draw its mouth and eye, as well as the remainder of its body. Start to render one of its legs.

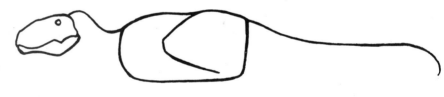

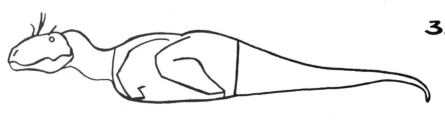

3. Complete its neck and tail, and further form its legs. Begin to create the crest on top of its head. Add its nostril.

4. Further render its legs, crest, and facial features. Begin to add muscle definition as shown.

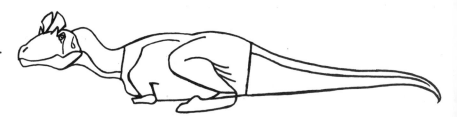

5. Continue to refine its legs, adding feet as shown. Sketch more facial detail, and erase unneeded lines.

6. Decorate its crest, and draw the lines on its neck, body, and feet. Add teeth, and then shade. Don't forget the round scales on its body.

Carnotaurus

ONE OF THE MOST BIZARRE-LOOKING DINOSAURS, THE CARNOTAURUS HAD SKIN DECORATED WITH LARGE, ROUND, EVENLY SPACED SCALES.

1. Begin by drawing the Carnotaurus's blunt head, complete with horns. Sketch the top of its neck, body, and tail.

2. Further define its horns, and add facial features. Draw its body with the hip.

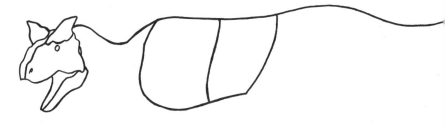

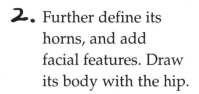

3. Complete its neck and tail. Add more facial detail, and sketch some muscle lines on its neck, body, and tail.

4. Draw its eye pupil, and begin to form its arms and legs.

5. Sketch its feet, claws, and teeth. Add muscle definition on its legs, and erase any unneeded lines.

6. Finally, further define its claws and feet, and render the scales all over its body.

GIGANOTOSAURUS IS THE ONLY MEAT-EATING DINOSAUR
DISCOVERED TO BE LARGER THAN THE TYRANNOSAURUS REX.

I. Start by drawing the top of this dinosaur's neck, body, and tail.

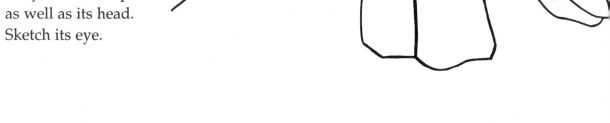

2. Add the rest of its body with the hip, as well as its head. Sketch its eye.

3. Further define its head, and begin to render its arms and legs.

4. Complete its neck
and tail, and form
more of its arms
and legs. Add
muscle definition,
and outline its eye.

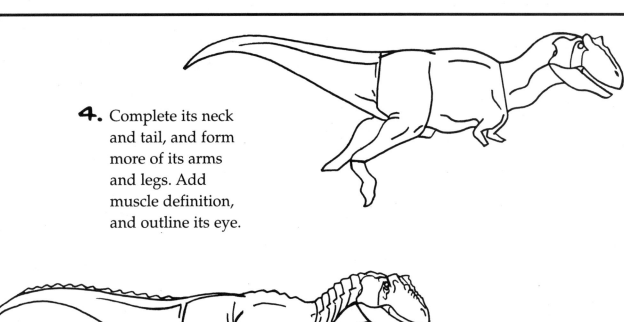

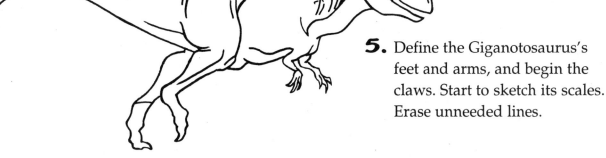

5. Define the Giganotosaurus's
feet and arms, and begin the
claws. Start to sketch its scales.
Erase unneeded lines.

6. Lastly, draw its eye
pupil and teeth, along
with the rest of its scales.
Refine its claws, and then
shade the dinosaur as shown.
Erase additional unneeded lines.

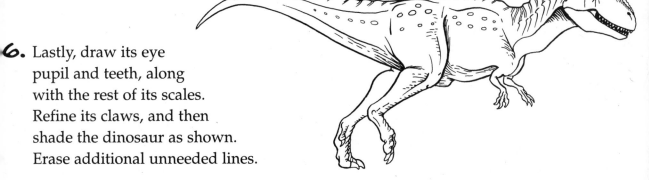

Oviraptor

THOUGH ITS NAME MEANS "EGG STEALER," THIS SMALL AND FIERCE DINOSAUR ACTUALLY TOOK VERY GOOD CARE OF ITS YOUNG.

1. Draw the top portion of the Oviraptor's neck and tail. Add its head, crest, body, and hip.

2. Further render its head, adding facial details as shown. Complete its neck and tail, and begin to form its arms and legs. Erase unneeded lines.

3. Add the bottom section of its legs and more of its arms, as well as muscle definition. Sketch more facial detail, including teeth.

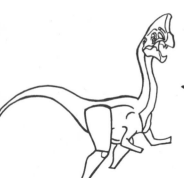

4. Attach its claws. Erase more unneeded lines.

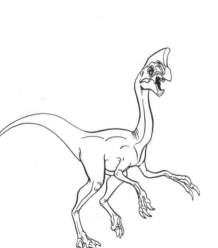

5. Refine the shape of its claws and feet, and add more muscle definition. Erase the unneeded lines.